As to those w.
and its birth
has been coming for a long time now.

In this book, I want to share with you
the rawness of my writing, my
experiences, my growth, and my
journey and most importantly;
finding myself.

I want to share with you a collection
my writing that aims to bring feelings
and experiences to life.

I have spilled my blood and tears into
this book.
Undoing many years of healing to re-
tell these experiences and hoping
someone will know they are worthy of
love.

We are All Worthy of Love.

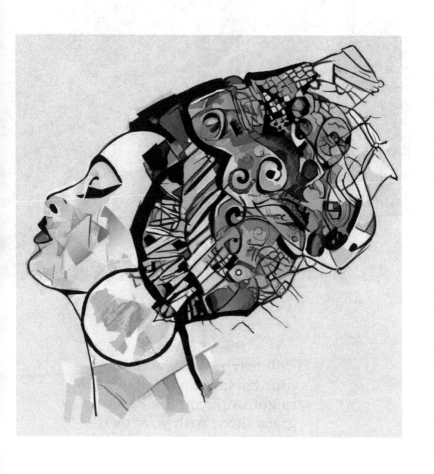

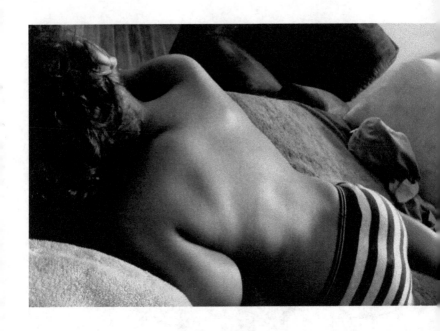

Sweet Child,
I will teach you how to keep
your back strong, tall, and
straight until you are ready to
grace those with your own
posture.

Braille

You remember the pressure of his
weight on you.
How you wrap your legs immediately
welcoming his presence.
He nestles his worries into your
chest.
You inhale his concerns, help him
unwind from his day.
He kisses you like he's needed to
unload the bullet from his barrel.
You feel the impact of his blows.
Touching him now consists of reading
braille to understand the silence he
speaks.
You feel home when he runs his
finger down your spine.
Goosebumps usually follow after his
finger.
You feel safe when you count his
breathes as he sleeps.
You always fall asleep before him.
He awakens when he feels your
absence or movement, needs to be
reassured that you will be right back.
His forehead kisses are prayers to
God to make sure I return to him.
Submitting to him was never an issue
with your stubborn self.
You daydream of his kisses on the
back of your thighs.

He always awakens you softly and
gently come morning, never rushed.
Your fingers remember the pattern of
his Braille....

You're suffocating yourself in your
own sorrows.
Because when he left, he took
fragments and shards of your
shattered/lost soul tucked into his
pockets.
He left a thirst in the back of your
throat.
You see yourself at the bottom of
bottles trying to satiate his thirst.
He left residuals and remnants of his
ashes under your lips.
Your tongue tries to dissolve his
taste.
You can't hug another man without
his scent sifting in your memory.
You can't smother his smell.
You remembered that with him - he
brought you structure. He gave you
posture .

So now you break your back trying to
remove the imprint of his hand trying
to arch your back.
You break and wriggle your body
trying to displace the memory your
body knows of him.
Instinctively, your body contours and
molds itself into his grasp.
You focus more on breaking the habit
of him.
It lingers.
He refuses to give you back
wholesome....
He tiptoes around the definition of
your lips every time you scream for
him at night.

Weighted

You feel the weight of him on your
shoulders.
You feel his skin sandpaper you until
you are smoother.
Obedient/
You give in/
Head bowed/
Compromise more than you should.
Your voice trembles when you speak.
His voice trembles the walls of your
safe haven.
The rim of your cup hits the bruise
on your upper lip, you flinch.
He etches "I love you" across your
face and chest.
You treasure those drawings.
You walk around with a clenched fist
as second nature.
You feel the "love" in your bones.

Make sure you are soft spoken, they
say...
Don't be yourself so you can catch a
good man's attention.
Be a lady...
Cross your legs and fix your posture.
Back straight/
Legs closed/
Don't let that scorned tongue speak
its sins.
Don't scathe skin with your razor
tongue. So we sever our vocal chords.

We let unspoken
words/thoughts/emotional
reminiscent residue in the roof of
your mouth.
Push it back down.
Swallow it.
Don't you dare.
Burn the tip of your tongue.
We appease men with our silence.
Smile and don't make him uneasy.
Comfort men with broken prides.
Soothe their reputations.

Make sure your presence makes
everyone uneasy.
Make people uncomfortable.

Maldigan a Las Mujeres

I've bared witness to the gorgeous of
men turn "ugly".
Warm touches exuberant with
lingering cold shadows, shadowed by
the ghosts of past loves.
Looking for the same face amongst a
crowd.

Empty skeletons tapping at their
sanity.
Bitter tongues que maldigan a las
mujeres.

Sleep is prohibited.

Most men begin to find themselves at
the bottom of bottles...
Their strings of hope suffocate them
at night, waiting for an end to their
misery.

Waiting for a little piece of peace.
They awake every morning to be
haunted by the same bed they've held
their lost loves in...

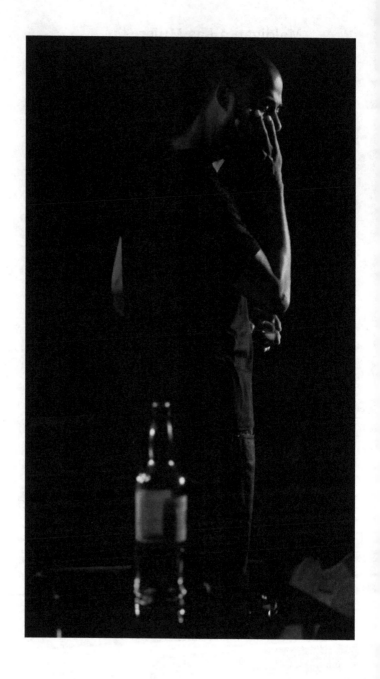

Altar

Mixture of rose water and incense-
Redeem yourself at my altar.
Come and whisper me your sins...
Kiss the grounds of my temple.
Read to me bible verses and runeth
your fingers down the middle of my
bible.
Arched backs and loud sermons.

Your tongue plays along the chords of
each curve...
I want you to be able to memorize
each letter to my body...
Come runeth thy tongue along each
syllable...
Let your tongue pronounce each
curve...
I will make sure you pronounce and
learn this body well.

Welcome Home...

I'm frightened that he saw the darkness in me too soon and that one day, it will scare him away.
They have all said they are going to stay and fix the brokenness in me, but they've all seen that the brokenness is not worth their time to mend.
I'm hoping that today isn't the day he awakens with my darkness hovering over his shoulder and he smells my sadness on his lips. That when I kissed him goodbye last night, would have been the last time I would taste his Light.
That one day he will realize he doesn't like to deal with depth anymore. Shallow waters are the easiest to swim in. That maybe the pounding of my waves will eventually have him gasping for air and he decides to breathe easier than deal with my storm.
I'm broken and I can't be fixed.
This sadness resides here, it won't go away. The darkness and tears have already begun building the mildew within my walls.
But he comes back with The Sun every morning...

Each morning, I admire his brave soul determined to love and cherish a tortured soul. Because he believes Light is still in me.

That when he feels the shards to my soul, he likes having his fingertips dance on the jagged edges.

He says he want to name my storms and watch my thunderstorms while sitting beside me.
He says he prefers to drink the sea breeze of my breaths and collect the roaring of my waves in seashells. He can put his ear to them and listen for hours the roaring of my sea....
He wants to hear the moans of my howling to the moon at night.
He wants to detonate the land mines he finds when his tongue tastes the bitterness in my mouth.
I want to water the thirst I taste under his tongue.
It's the moonlight in his eyes that helps me see the reflection of myself... His Light calms the Storm in me...
Thank you for coming Home...

Welcome Home!

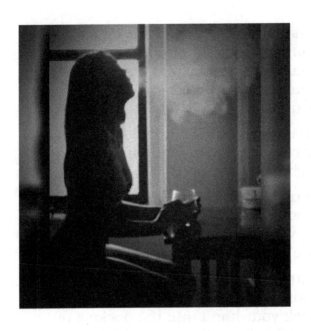

[Caging Demons]

You know you've spent countless nights knowing the tiles of your bathroom floor as your tears flood the indents of where the caulk begins to grout with your sorrow.

You know you've spent nights muffling your cries so you wouldn't awaken your child. Where you've prayed on your bedroom floor as your soul ached. You've convinced yourself on those days you felt shards of your shattered soul prick you in your ribs; that you are worthy of happiness.

That on drives where you were alone, your tears would puddle between your thighs and gasps for air were masked by the radio playing. You're petrified.

That you would light candles at night hoping your soul would imitate the Light.

You hope that your sonnets to the Moon will lessen the heave of her flow on you when she comes looking for you at night...

You pace yourself trying to keep your sanity for days at end. And that you stick your hand into the pockets of Sunshine you have stored for the days you wake up gasping for air. You catapult yourself into distractions.

You have been waiting patiently for this Darkness to hover itself and pass over you.
I'm trying...Some days I am victorious.
Other days, I don't even put up a fight.
I'll take the beating.

Stay

I close my eyes and feel your lips on
the nape of my neck....
I feel your warmth radiating off of
you.
My skin absorbs the heat being sun-
kissed by your rays.
I'm completely surrounded by you,
prisoner to your arms, I'm chained by
the sweet serenading your fingers
play along the chords of my skin.
Kisses that sing lullabies and drink
the moonlight of my skin.
Silent stares and enveloping touches
that lick, close and stamp with your
tongue along the edge of my hipbone.
I feel....
I feel you...
Blinking....
Intertwined, we lay, I study your face.
Every indent and definition I embed
into my memory.
Fingers slowly walking up the hills of
my waist like a nomad. Your
fingertips color within the lines of my
soul, reaching and speaking to
intangible places that I never knew
were there.
Stay...
I caress your chest, feeling your
breathing.

Watching your every exhale, waiting
and hoping that you breathe me in
and exhale beautiful thoughts and
memories of me that pollute the air.
I....
I....
I want to play hopscotch on the tiny
crevices of your lips hoping not to fall
between the cracks.
I want to sing you sweet everythings
into your mouth, suffocating your
lungs with residual of my nasty
nothings.
Stay....

I slowly open my eyes and realize I
am awake
and you.... Are just a vivid image of
my imagination

Birth of A Mother

God licked and stamped the envelope
of the letter, when He signed off all
beauty and innocence when he
packaged you for me.
The first day I laid my eyes on you, I
knew that God intended to deliver me
from evil with your sanction.

The roar of the ocean in your voice.
Your dimples are spoonfuls of honey.
Your smile is God's handwritten love
notes to me.
The glisten in your eyes are Yemaya's
kiss goodnight to the sky.

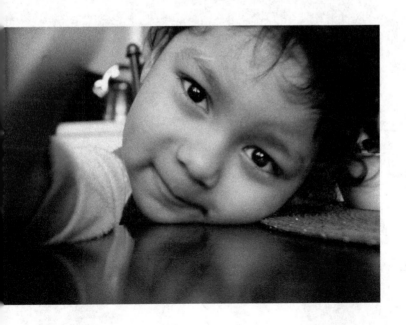

Beauty/Light/Pain

Stop watering the plants and flowers
of those who don't care to tend to
their own beauty.
Stop Lighting candles for those who
will only blow out the flame on the
first sight of Light.
Stop healing the scabs of those that
pick at them at night because they
enjoy the pain.

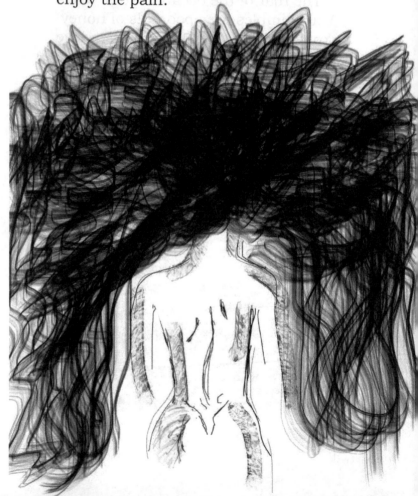

~~Godly~~

Because when she exhales, she exhales all her fears and doubts she has within herself.

She is like smoke...you'll smell, taste, feel, see her but she is gone the moment you think she is yours to tame.
She confides in the Moon to light her path. Even the moonlight lingers on her skin for her warmth.

She is the fresh breath of air that frightens you.
Do not grow comfortable with her scent.
Her eyes tell stories of great wars fought.
Lips that serenade and arm the hopeless with Strength.

Her beauty that silently kills but humbles.

Nunca fue tuyo para Tener.

I'm ready to fill the empty canvas of
your back with goosebumps.
I'm ready to nestle and cradle your
head in my lap on those days you feel
broken.

I want to stop the quivering of your
lips when you can't sing your soul.
I'll play you the melody on those
days.
Come fit your hands inside my shirt
when you need to be reminded of
warmth.
I want you to yearn for the cold, so
you come running to me.
I want to nestle my ear to your pulse
and use that tempo for my hymn.
May the water hitting your back in
your morning shower remind and
mimic my lips and licks.
That when your bottom lip nestles
the rim of a cup, you remember the
curve of my breast.
That when you bury yourself into
your pillow that it gives you
flashbacks of you burying yourself
between my thighs.
That I haunt you throughout your
day and the only antidote will be my
taste.
That as your fingers turn the pages to
your favorite book, you are reminded
of playing between "my pages.

Undone

Hold me at the seams of my soul,
nestle your fingers to mend the
cracks...
Remind me what it is like to taste
your smell.
To know what it's like to be held
together.
Why do you work so hard to keep me
intact?
I'll still undo your sewing when I
don't feel worthy.

Perhapsjust maybe he will run
his fingers through my hair and
untangle strands and lost hope.
And just maybe when he kisses me,
he will be able to undo the safety pins
from my tongue so I can speak easily.

And just maybe...
.
.
.
.
The Next morning when he sees
pieces of myself shattered/undone
spilled onto the sheets, he will change
the sheets with me and lay down a
new foundation for me.

Offerings

I line my lips with the blood of my
Ancestors.
I no longer try to tame the Curls of
Yemaya's Sea Breeze in my hair.

I'm reminded of the God in me every
time I have to Taste the ashes of my
past on my lips.

An offering made to my Lineage.

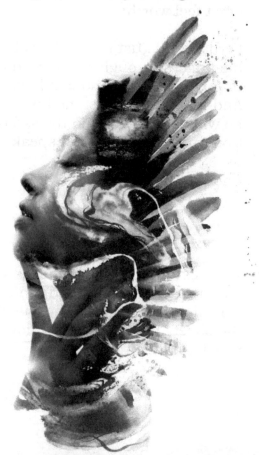

God/dess

You don't have to show the crevices
and indentations of your bones for
"them" to see your beauty...
Pull your skirt down just alittle...
/Temples are sacred.
Allow your "holy water" to quench the
thirst of sinners/
You are Godly.
Your eyes have been handed down
from our Ancestors.
See with Their Light.
 Your Skin was woven by your
 grandmother.
Your tongue has been sanctioned by
your Mother, learn to cut precisely
with each word.
 Your Grandfather welded Your
 Brightness from his tired hope.

We must never forget that Our
Ancestors prayed for us to conquer
what was once theirs.
Our mothers lit candles & prayed for
us to have thicker thighs, coarser
hair, & wider hips.
They prayed for us to be the rebellion
in the flesh. Sway our hips to sing
their songs, untouch our hair to
answer their prayers, and allow our
thighs to clap to their memory.

I hope you are all able to experience a
love that doesn't excite you but
instead brings you calm & peace.

A person that is willing to sort and
untangle the knots in your throat.
I hope you find a love that settles the
bombs in your chest.

A person that will knead the doubts
out of you....

I wish I can write the way thoughts
hug tightly at night.
I wish I can write profusely like blood
spilling...
I wish I can write like I starved for
many months hunting f
I've written myself into anxiety
attacks...
And I've written myself out of them.
But somehow, my thoughts will waltz
their way to you no matter how hard I
try not to....
I wish I can write about you the way I
thought about you.

There are a few things he didn't know
about me. He didn't know that the
ashes of past lovers,
I carried them under my fingernails
and tongue.

These lips he kissed/they've
detonated too many explosives and
caused too many wounds.
This tongue has eased the death of
tormented souls.
My battered skin has the licks of
wounded soldiers.
I've tried to salvage.
He doesn't know that he holds hands
that have cradled broken bones./
He doesn't know that when his
tongue cradles my breast, he revisits
the museum of war heroes who have
died trying to conquer me.

As he unglued himself off of me, he
realized that I was an
unforgivable sin.
That no matter how many Hail Mary's
or Padre Nuestros- he would never be
able to repent or shed the act of me.

In the midst of the storm, he leads
me to the path I veered from and
guides me to the Light.

Morning Coffee

\Mornings arise…/
I still brew this anger you left stirring in
me with the tears I've collected.
I sip this anger.
My cup overflows with the
memories of you.
I cradle the memory of you delicately;
holding onto its warmth, reminiscing the
sprinkles of your sweetness.
I rub you out of my eyes and brush your
taste out my mouth.
You pool yourself in the back of my throat
making you hard to swallow.
I have to remind myself to breathe.
This batch of you sits heavy on my palate
today. Your essence is strong and leaves
me jittery as I try to wean myself off of you.

CPSIA information can be obtained
at www.ICGtesting.com
Printed in the USA
BVHW012125041219
565649BV00004B/88/P